CW00553335

Responses to the book

Sandi Steward's beautiful pastel works capture the essence and subtle beauty of the humble mangroves that clothe the mud flats of Western Port. Thank you Sandi for sharing so generously your uncertainties, your research, your successes and your vision now found in this book.

David Miller
Artist and children's author

Your book - your journey through it - has reminded me how all individuals with our collective thoughts become entwined and inter-mingled as we each follow life's progress. The experience has been refreshing and inspirational – a rare treat - thank you!

Norm Duke
Mangrove ecologist

Sandi brings readers along on her journey and implicitly encourages them to identify their own authentic pathways to connection. Her mangrove artwork is beautiful, her text is a joy to read and the book is beautiful in its simplicity. It has a message for everyone, "This is how I have connected with the universe through mangroves".

Pat Macwhirter
Chair of the Healesville to Philip Island Nature Link.

... a fascinating very personal, holistic journey, concentrating on far West Gippsland and Westernport. Sandi's descriptive words and captivating images provide marvelous insights into nature as she comes to understand the importance of these amazing plants. Sandi, you are a 'champion of mangroves' and we are the beneficiaries.

Rodger Elliot AM
Co-author: The Encyclopedia
of Australian Plants suitable for cultivation.

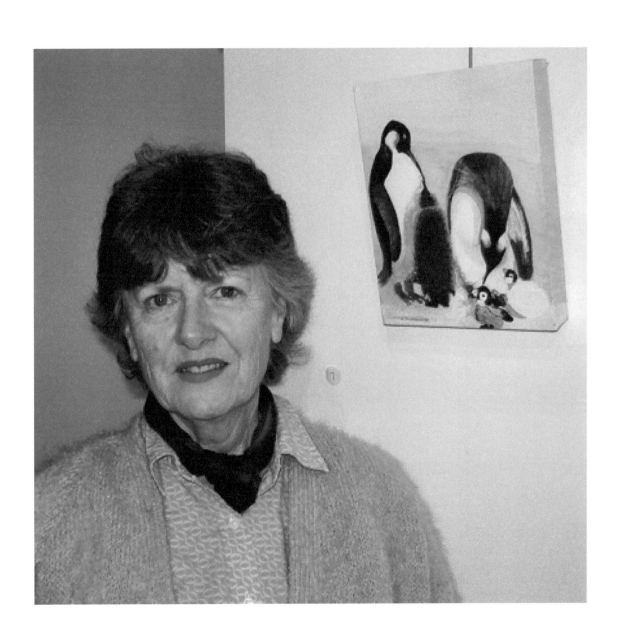

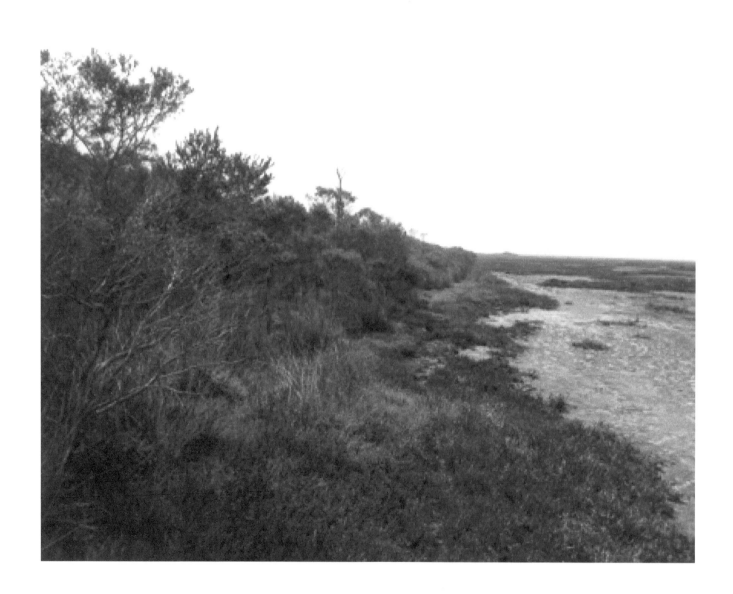

The Nature of my Art

by Sandi Steward

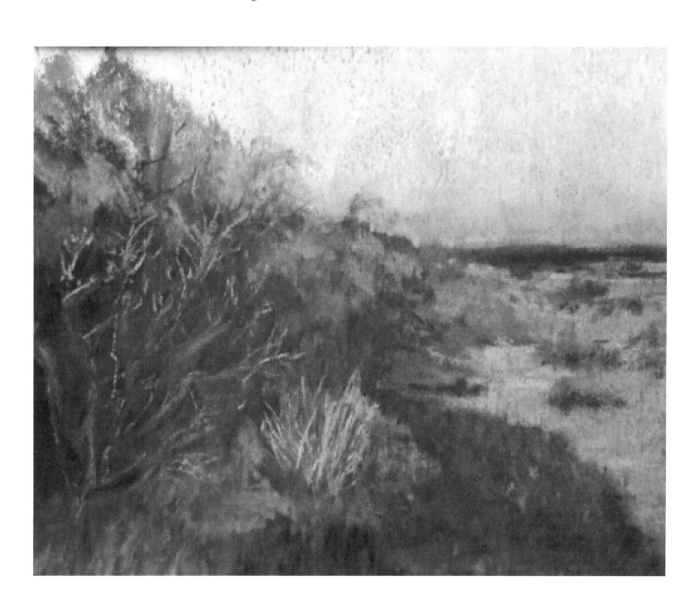

Publication details

The Nature of my Art

ISBN 9781649215260
© Sandi Steward

INTRODUCTION

Jill Parris generously offered to publish these musings on the green and brown theme. My annoyance about the mangroves' green and brown palette has been gradually lessening over 15 years of dialoging with them.

Now, the journey is over-taking me with wonder at their 'Blue' label due to the mammoth amounts of carbon they sequester. With Joseph Campbell, I sense that "Awe is what moves us forward" on this publication that combines my previously exhibited work, my 2019 article in Eremos, and other personal notes.

Most of my pastel works were begun in class or at home on my student easel, feeling my way from an urge to paint a scene to which I was strangely drawn. Despite being embarrassed in landscape classes fellow senior students cheered me on respectfully and inquired about this unfamiliar type saltmarsh or that tidal scene.

I've spent much of my life learning new skills, then moving on to something else, but publishing this book has meant revisiting my works and being even more delighted with them than I could have imagined. Scanning through my photos of reference material I found more early works than I had remembered painting.

Far West Gippsland and Western Port, where I have put down my roots, are remarkable and rich terrain. I hope you enjoy this glimpse of its mudflats, saltmarsh and mangroves.

All of the artwork and photographs (except for four) are my work.

Sandi Steward
Cranbourne, 2020

PS: During the Corona-19 lockdown I gave my grandchildren (all artists in their own rights) the opportunity to vote on their favorite pastels in the Mangrove Musings Catalogue. You will find their responses towards the end of this book.

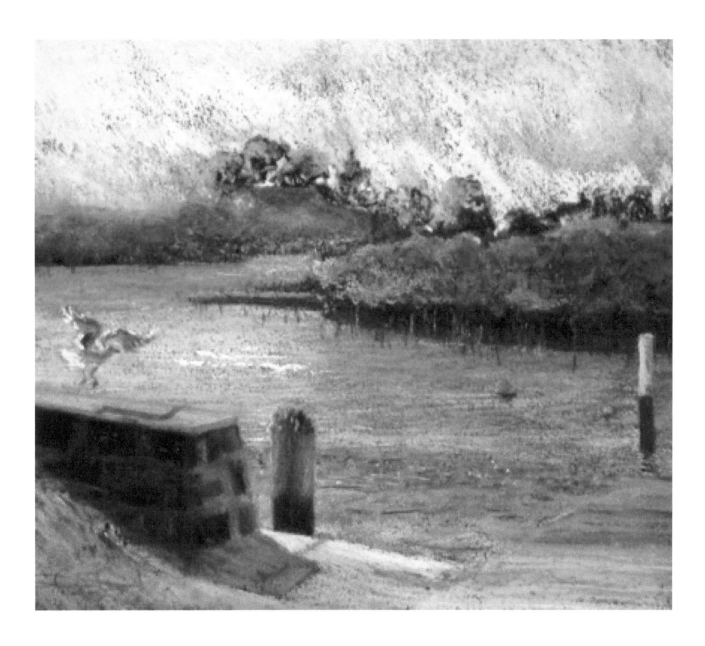

DEDICATION

Grandma Osborne had a gift with water-colours and I grew up with one of her landscapes in my lounge room.

Sadly she was not able to develop her career due to family commitments and limited economic means.

Her memory has inspired me and my work.

I also remember with gratitude my great-uncle Arthur Stace (Grandma Osborne's brother-in-law). As a street artist, who only used yellow chalk, he was known as Mister ETERNITY. For years he drew this one word on Sydney streets in perfect copperplate.

Acknowledgements

John's tasty meals produced over several years while my evening pastel painting energies peaked, and his dedicated word processing and editing during the 'Corona' lockdown, made this book possible.

Bringing my work to life has reminded me of the community of people who have surrounded and supported me, in the way that mangrove trees support each other.

This includes, but is not limited to:

Mum Hinds, my siblings, Simone, Adele, Esther, Jill & David Parris, Kristin & Martin Vargas, Jill Manton, David & Sylvia Miller, Barb & Morris Stuart, Di & Ken Inchley, Phyllis Veith, Nain & Peter Philp, Val & Keith Butler, Mary McCowan, Ros Wright, The WellSpring team, Sophia group, Dr Pat Macwhirter, Alex & Pam Packett, Dr Norman Duke, Dr Vishnu Prahalad, Sue Jennings, Micheline & Brian Jones, Elly Abrat, Cathy Van Ee, Friends of PAS, Jack Stuart, and Frances MacKay.

MANGROVE MUSINGS.

The quest for an open-minded engagement with nature is as challenging and uncertain for individuals, as it is for communities and corporations. We need a more intimate acquaintance with the phenomena of the natural world. In the words of Tim Winton (Island Home, 2017) "we need to feel them in our bodies, claim them and belong to them as if they were kin".

From the first time I felt mangroves in my body, the reaction was coupled with empathy for them, isolated and struggling 'on the edge' of our wetlands, salt marshes and continent.

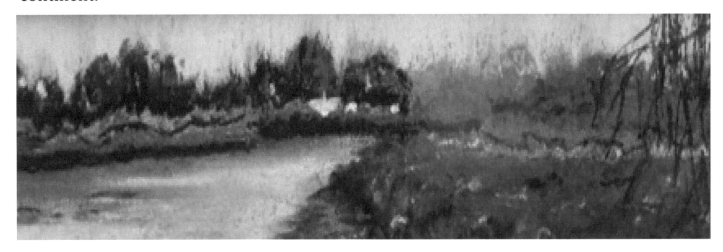

The journal 'Eremos' of August 2019, pp 37- 42 forms the foundation material for these musings.

I have enriched that material by adding practical, historical and visual material.

BAYVIEW ROAD, TOORADIN

Low tide High tide

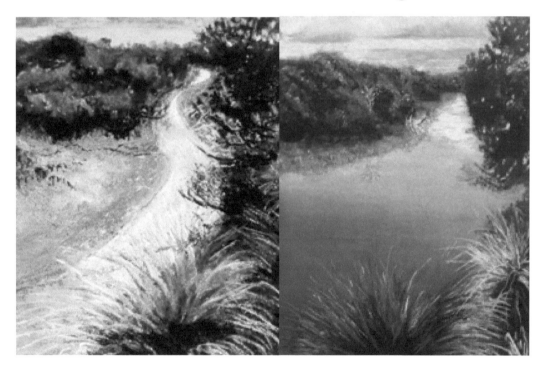

I was dumbfounded on noticing the rates of movement in the tides: sometimes full and slow, but later thinner and hurrying.

Twice every day the tidal rates move from 1-2-3 then 3-2-1. This is known by sailors, fisherpeople and surfers as 'The Rule of Twelfths'.

As I mused on my own pilgrimage involving art and nature, I am sure that it germinated 30 years ago. That was when I found us an unfinished house in North Ringwood, with windows to the west, framing views to a dam edged with indigenous plants. Neighbors proudly told us how last century First Nations' women had walked this valley towards the Yarra River and named it *The path of the Flight of the Black Cockatoo.*

We always referred to the Reserve as Yanggai Barring...at first unappreciative of the habits of black cockatoos and indigenous plants, then becoming intrigued and delighted.

As I soaked–up sunsets over the Eucalyptus-filled gully, unconsciously I accepted their beauty while continuing to need the autumnal cycle of Liquid Amber trees close by, since they still grow in my childhood garden in Blackburn.

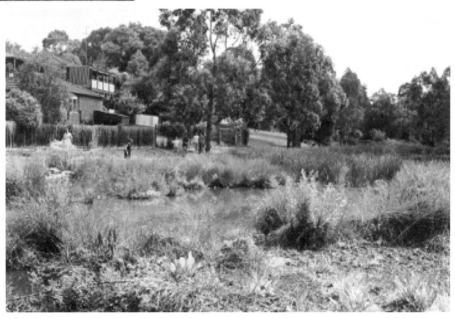

The dam at the bottom of the slope.

OUR GARDEN

31 DEC 2004

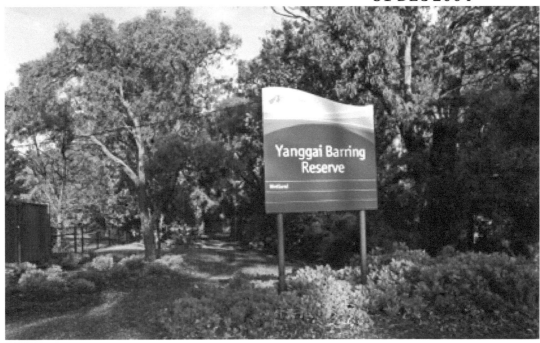

I planted veggie seedlings in beds, while John dug deeply to establish fruit trees. We were inspired to try indigenous flowering shrubs. The bees had a ball!

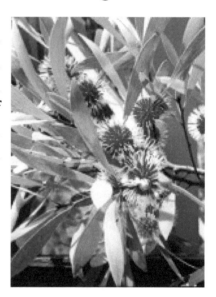

I joined the local economic trading group to exchange services among new-found friends, established my naturopathic clinic and discovered the worth of relaxation and meditation, which I soon began to teach in this peaceful setting.

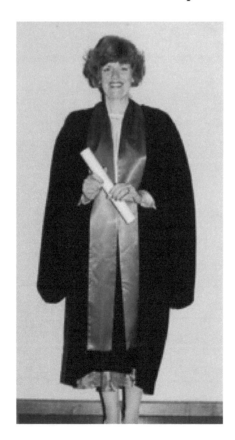

It's probably not surprising to have thrown myself into planting vegie gardens here. I made my mark on every block I've occupied in Australia by digging soil and throwing in seeds. Thanks Mum and Dad.

During my ten years on Java it was too hot and sticky to do my own gardening. Moreover it was more prudent and sensible to buy vegies and herbal medicines from the street sellers .

This peace was challenged by going to Rwanda with my husband in 1997 where we found considerable unrest and dysfunction. My personal comfort was overlaid with the heaviness of the stories of pain that women would tell me. My equanimity was retained by nightly meditation.

Two predominant colors to impact me in Rwanda were the brown faces of the people I came to respect, and the vibrant greens, symbolizing growth of a country recovering from devastation. Women in Rwandan national dress brought delightful accents onto this green and brown landscape.

After we returned from the green
and brown of Rwanda, friends
joined us monthly to pray for
'Places in Despair'.

At the nearby neighborhood
center I took to Life Drawing.
Living amongst the aftermath of
genocide had diminished some
of my issues around body image.

By early 1998, I was enjoying art
classes.

This single, line drawing was my
first exhibited piece.

By the thirteenth year on this block I was happily earning my degree at the Australian Catholic University ACU.

Prior to writing my final essay for ACU and packing up again we held a "House cooling" with twenty friends.

We moved to a unit closer to our grand-parenting zone, but not too far from the golden sands and blue crashing waves of my favorite childhood holiday places.

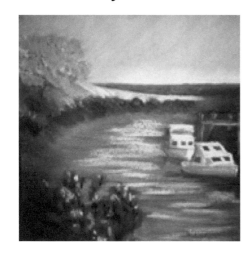

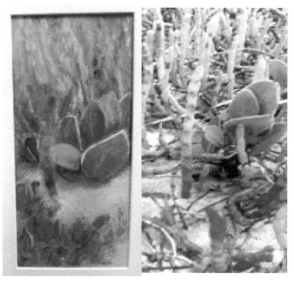

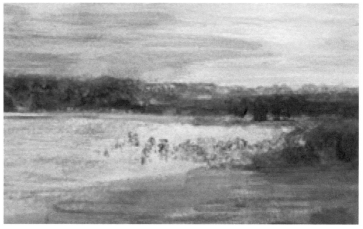

I made a brief foray into portraiture at U3A, Cranbourne

Then I moved into pastel painting around Wilson's Promontry and Sandy Point. Peaceful scenes of sand-hills, shallow blue waves, gentle inlets and oh, the pelicans and black swans!

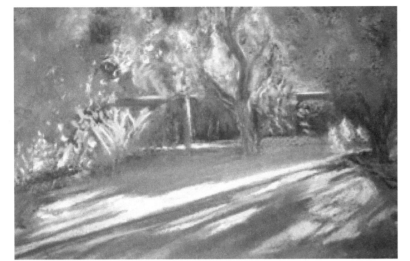

Ah yes, light and shadow!

The two most important aspects of my work.

While packing for breaks from our tiny new unit I was cautious about how I would take in the ambience considering the cottage abutted salt marsh.

MELALEUCA SHADOWS

With sand hills I should have quickly felt at home in Sandy Point because the vegetation was mainly Melaleuca (tea-tree) which I'd grown to love when trudging over sand hills and Kananook Creek from my aunt's home, to reach Frankston beach!

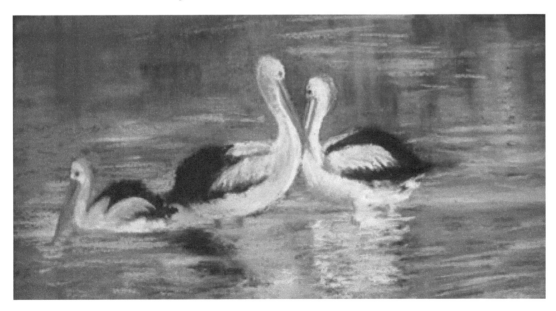

Now to reach grandchildren I was regularly wending my way past dairy farms, up and down curved roads, through pretty towns, overtaking milk trucks and buses.

The first feature along the highway was the mangrove territory that skirts the coast of Western Port.

TYPICAL TOORADIN

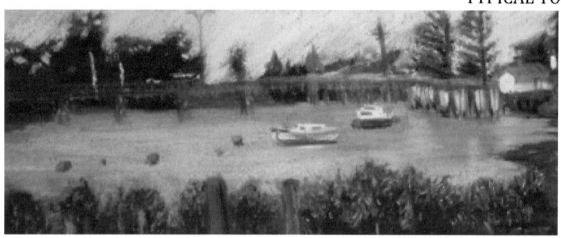

The most welcoming gateway to Gippsland holidays and retreats is in Tooradin. Parts of the old jetty are in the foreground (above), while the highway is in the background

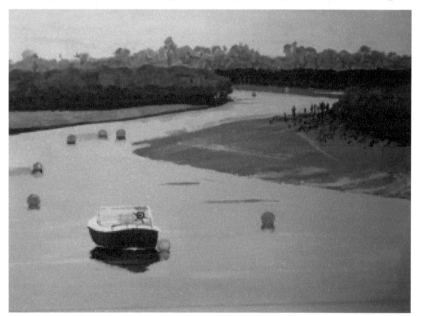

Tooradin's slow-paced, child friendly tides and miles of mangroves, stand out at low tide.

Before long I was searching out new views, angles, nuances, nooks and crannies. All the works on these two pages are from Sawtell's Inlet in the heart of Tooradin.

GLOWING INLET

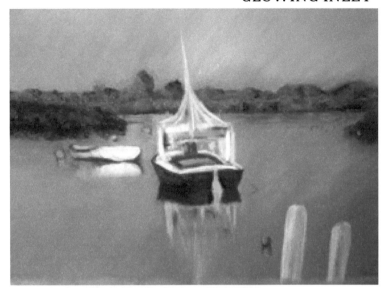

The inlet is glowing at high tide in the morning light .

My best boat works were from this inlet. It's been 6 years since I began trying to paint pleasure craft.

POST MONET

My most satisfying result of dark colors and reflections

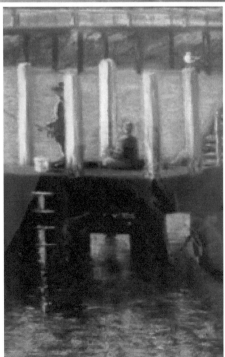

Allowing mangroves themselves to recede in paintings…I paid more attention to the saltmarsh "community" surrounding the mangroves. My focus changed track as I discovered the delight of bird life, inlets, boats, saltmarshes and grasses.

My reactivity mellowed as I gradually broadened my interest to include the unappealing mudflat areas with brown, seeping tides, a nursery for mud-crabs, fish, mosquitos and samphire.

This land-form predominates in an internationally significant RAMSAR Tidal Zone (Convention on Wetlands of International Importance).

STILL FISHING FOOTPRINTS IN SALT

TOORADIN GULLS

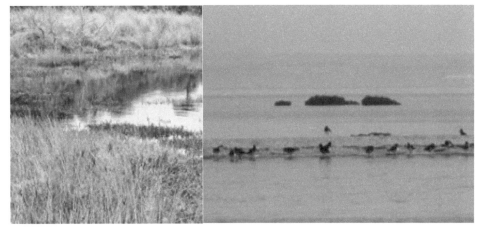

GRASSES PIED OYSTER CATCHERS

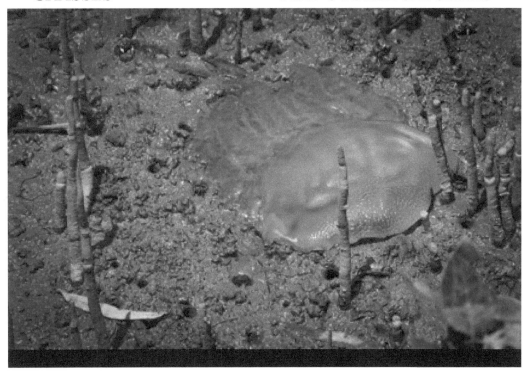

©David Fullerton

This mud-flat is a nursery for mud crabs.
Note the multi-functional mangrove aerial roots caging the dehydrating jelly fish.
The latter are often seen with mangroves and algae in a symbiotic relationship.

It was then that my curious relationship with mangroves began. Mangroves were the last form I expected to enjoy painting. Reacting to their boring green and brown, I wondered if I could find colorful ways to paint mangroves.

'From Gus' Jetty' (opposite page) was an inspiring work. The impenetrable habitat was flooded enough to reflect the sky and a sunbeam.

All tidal movements around mangroves involve sediment-laden water; naturally, that is brown. However most of my paintings have blue water because they are reflecting the color of the sky.

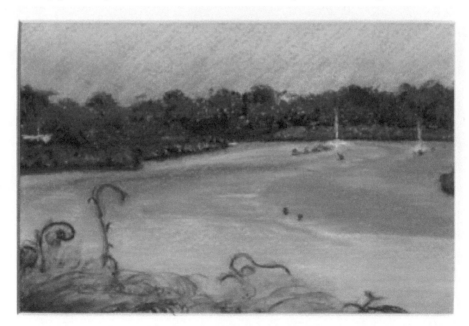

Where was this preference for 'anything but boring' coming from? Why am I now championing this seemingly ordinary plant and its environs? How did this passion come about?

I became aware of a strong inner struggle: I was annoyed by their lack of interest in the landscape – their flat, unvaried coloring. Moreover I feared that if I focused on painting mangroves, I might die of loneliness!

Where was this taking me? I decided to search for the meaning of this strong, irrational reaction.

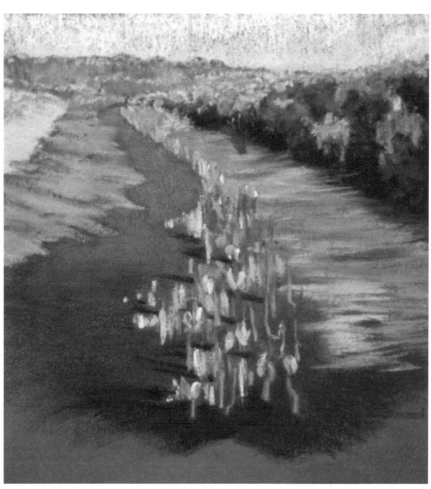

PIONEER BAY

TOORADIN SHIMMERS

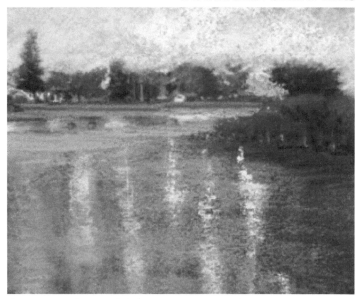

How mysterious that 'reactive' would be my initial feeling about natural phenomena.
I remember the early sense of foreboding about starting to paint mangroves.
It seemed almost impossible to respect the One who knew me and my inner dynamic.

MANGROVE SEEDLINGS

MOVING FROM HISTORY TO MYSTERY!

I began appreciating the mechanism of reacting when I learned – thanks to Magdalen Smith's Fragile Mystics (2015) – that Freud had suggested 'we most passionately defend our individuality by differentiating ourselves from those to whom we feel most alarmingly similar'.

I accepted that insight because I like to be different from those around me. I needed to understand this mechanism as I had moved into a retirement village of 200 residents, where we are all over the age of 60!

For my WellSpring
I used blue cloth
But I was more
art to introduce
dentritic-patterned

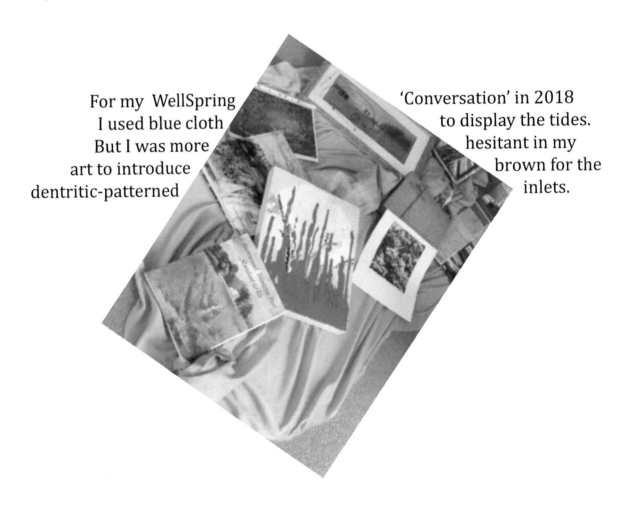

'Conversation' in 2018
to display the tides.
hesitant in my
brown for the
inlets.

EVENING GLOW TOORADIN

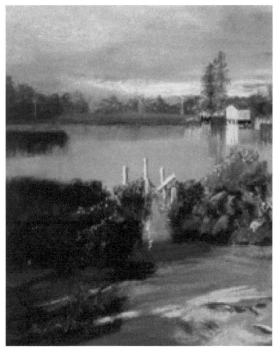

From the upstairs of HAREWOOD HOMESTEAD

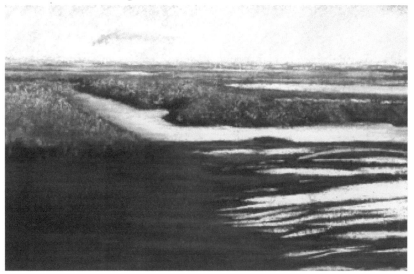

Overlooking the shadows cast by ancient cedars and
out past mangroves to Western Port on the horizon.

Then I wondered: How similar am I to mangroves?
I was helped by Tim Winton's suggestion that Nature is elusive, enigmatic and at times resistant. He says: 'Sometimes I think it's sufficient to admit you are mystified'.

For example: how and why can mangroves put out two different types of roots?

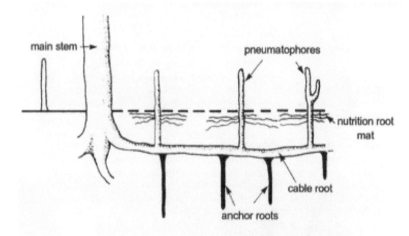

Source: Harewood Nature Guide, p 20

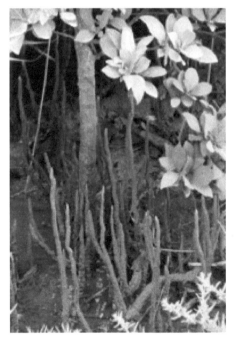 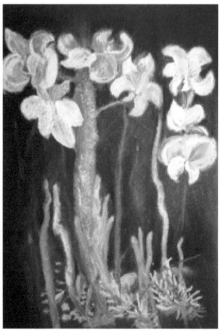

Propagules putting down roots into sediment are likely to grow stronger than when they're only on sand.

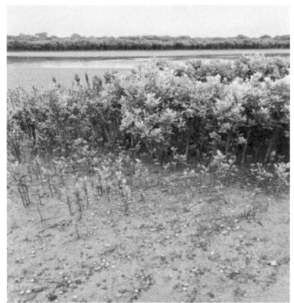

Propagules washed

up onto sand along

the high-tide line

in Rutherford Inlet.

Their future is

uncertain.

One day from out of the blue I thought 'Mangroves are of little use. Do I also present negatively as stiff or positively as stable, like mangrove foliage?'

Gradually mangroves became a way into a growing awareness of my weakness, strengths and capacities.

Mangrove (l) and Scrubby Samphire (r) like each other's company, and can match each other's height. However Samphire needs less inundation.

It seems these days, 22 years after returning from Rwanda, that I am living with less inundation from Rwanda, just as Samphire needs less inundation.

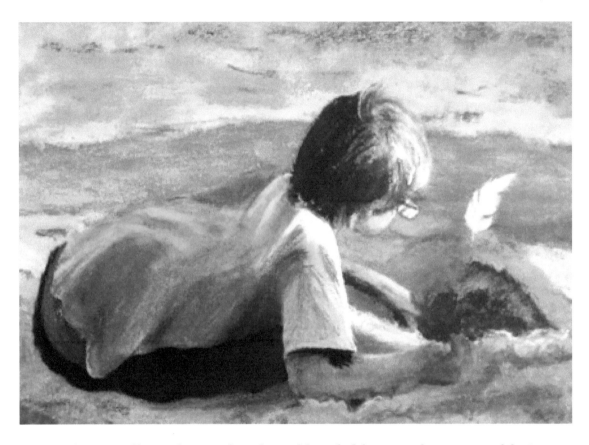

This small sandy patch is loved by children and parents alike!

The remaining inlet margins in Tooradin are sediment.

The shadows of nearby mangroves sheltered this child from

the hot sunset.

I naturally try to beautify my surroundings, and share my love of colour and design. Appreciation of nature is integral to my personality and I love pointing others to what I enjoy.

My early mangrove musings however, showed I was unimpressed by their lack of visual appeal. I had no urge to sing their praises!

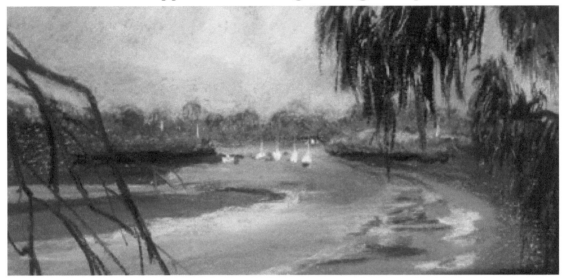

Pastels lend themselves to accentuating colours, bringing the scene to life. The kayaks below are wending their way through the mangroves at high tide not far from Harewood Homestead.

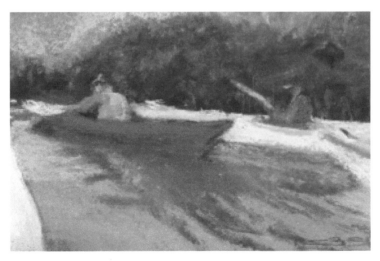

By contrast Samphire's most attractive portions are its dying sections that glow like pomegranate seeds.

Initially the surrounding slime and dead leaf matter were unappealing to me, until I learned about the life of saltmarsh and the inlets where they are found.

Grasses, once overlooked, are now valued.
I hoped to capture the glow that is the highlight of the scene.

The solitary mangrove in the foreground may not do well,
as communal living is strengthening for mangroves.
You are my most enjoyed work, according to viewers.

SIGNIFICANT VEGETATION

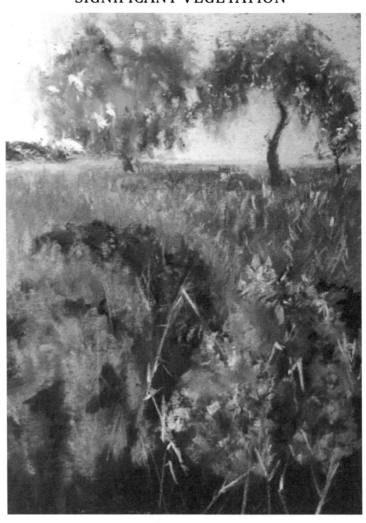

Gifted to Adele

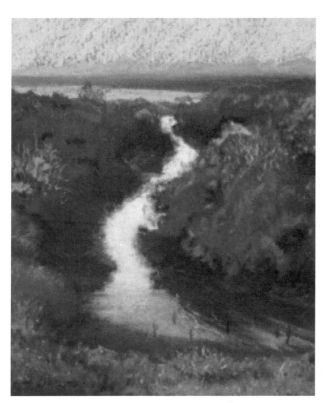

Reminders of Robert's 'Silver Moon' amongst the nursery in this tidal drain. Tiny prem-baby mangrove plants staying close to the parent plant.

Elegant shine contrasts with dull mud banks. Only half a km to the pasture in the background.

I no longer feel apologetic when viewers ask about this work.

The pastel below is true to Western Port Saltmarsh. I gave you a lavender highlight so viewers would find you attractive

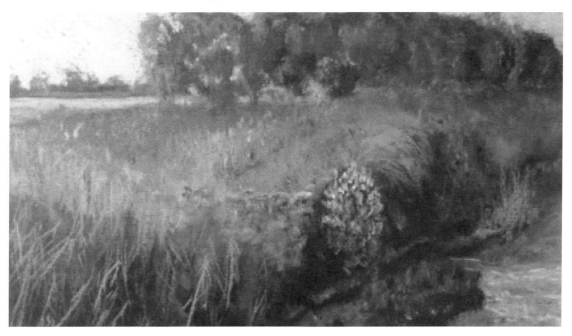

The dense structure of mangroves means I can't pick them for my dining table; but I obviously needed to include them in my art because I kept being drawn to them.

Their limited range of color is not my kind of beauty!

Once I lamented, 'Why wasn't I drawn to paint myriads of roses or indigenous flowers?'

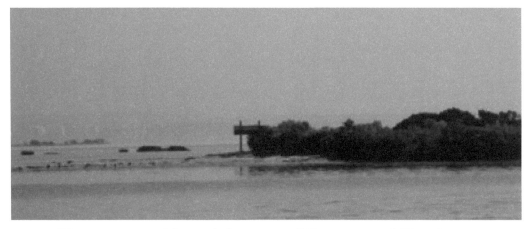

Mangroves mid-strait between Warneet and Hastings
Their roots hold the sand for a bird sanctuary

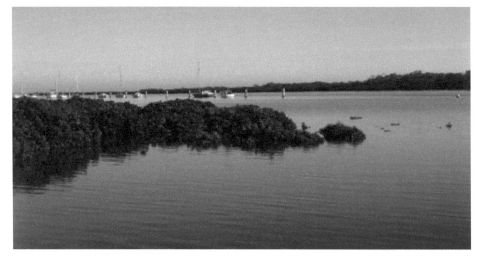

From Warneet boat ramp, mangroves to the left and right.

LONE MANGROVE

Birthday Gift to Simone

SALTY BOUQUET 1.
Here is one mangrove I did enjoy. You
may well have been my first painting.
So beautiful – I found you growing
about a km from Western Port, laden
with what you are designed to
balance: the salt in the muddy
sediment.

I want to share this bouquet
with other admirers.

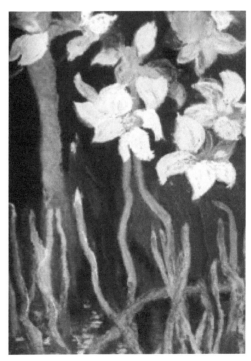

Only later was I delighted to realize that mangroves are not just there for their own sake but as guardians of the shoreline.

Bearded Glasswort/ Samphire in the foreground of this picture is happily growing further up the shoreline with less inundation.

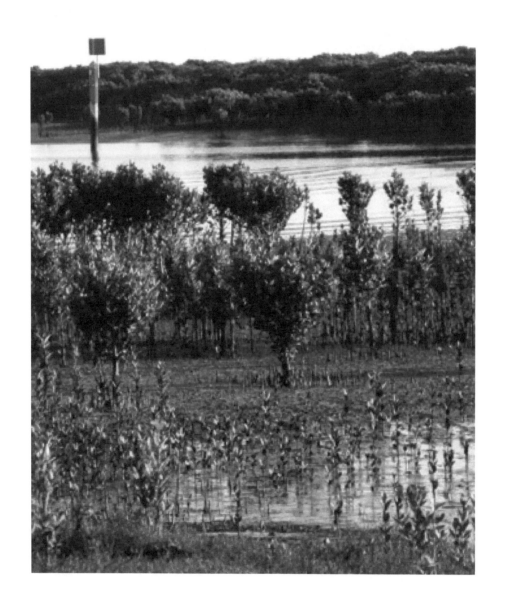

FROM THE BLUFF TO WARNEET

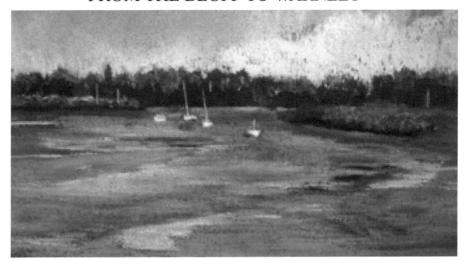

REGULAR RIPPLES

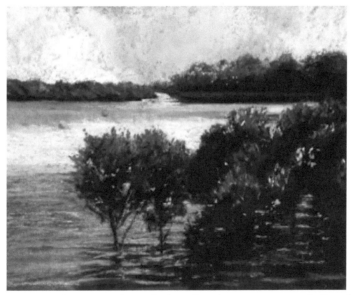

You gave even more delight when I painted the ripples to my satisfaction! Reflections and ripples came together. How amazing to see those ripples as the rising tide brings water through the trunk. Contrasting light and dark flashes of blue, not brown, under bushes. No mulch is needed because of the rich sediment.

To enjoy painting mangroves into landscapes I looked for colorful settings that kept the eye moving around the paper. This increases the time viewers spend looking at the work.

The Golden ratio, or Fibonacci sequence, has been a handy concept to guide the layout of my painting.

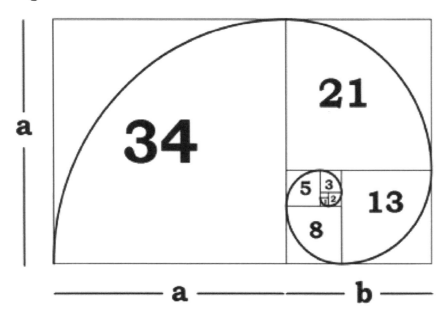

The Fibonacci spiral is found widely in nature.
This device aims to enable a viewer to stay with their eyes on the scene, not leaving the page.

EXPLANATION
In the picture opposite:
a. Rocks in the foreground invite me onto the scene with their flashes of yellow and pink,
b. My eye is then led up to the apricot clouds,
c. Around through mangrove island, and
d. Finally down and around to my 'hero point': a pair of young mangroves establishing

MANGROVE ISLAND

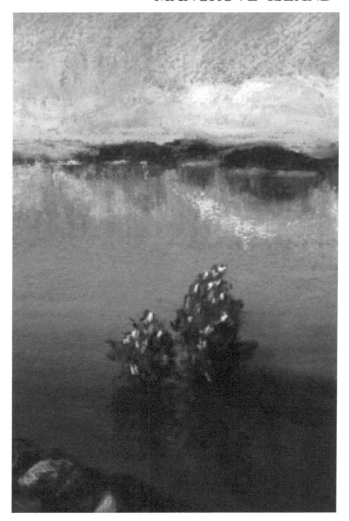

Recent research in Singapore shows that the density and width of mangroves correlates to the reduction of wave height during a storm event. This important stifling of the waves is greater for mangrove roots than for trees with trunks and canopies.

The Mangroves in the background of this drawing supports the unique ponding in the island because the mangroves that grow around the periphery protect it.

I grew to experience art more deeply whenever emotions were evoked by the work.

Like the artist John Wolseley, I seek a 'revelatory moment' behind each piece. Despite this new awareness, I still struggled to see mangroves as beautiful.

One such moment came to me as I experimented with ideas of cards or brooches. As I tried to make these using a part of the cover picture to this book, the awareness came:
"Crashing waves are not me".

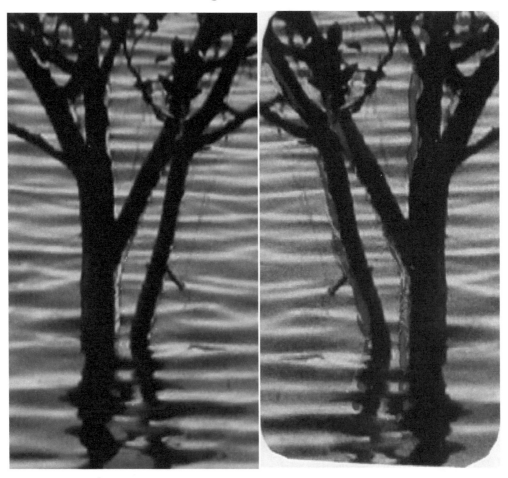

I never found a
revelatory moment
about this picture.

Five attempts to paint
it, and rudimentary
efforts to construct
some play doh buds/
flowers,
were unsuccessful.

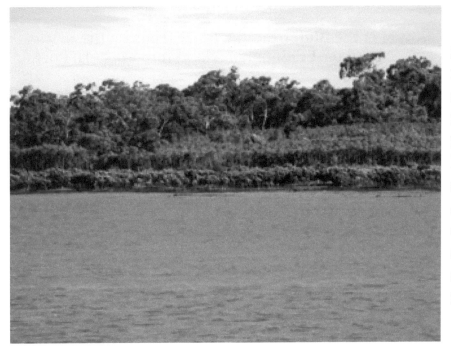

Layers in
inlets of
mangroves
do not
interest
me.
But turn it
sideways
& this
could be a
design for
a stripe of
fabric.

The area between the Bluff and Warneet is one of my favorite parts of Western Port for observing and photographing mangroves. This page has two photographs on which I based the pastel pieces opposite.

PHOTOGRAPHIC REFERENCES:

High tide

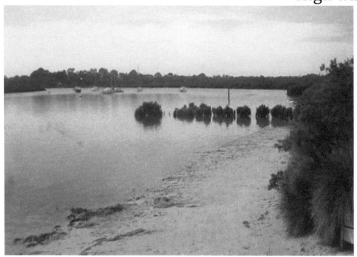

Rutherford Inlet flows via the Bluff from the far reaches on the Right, through Warneet and past Chinaman Island into Western Port

.

Low tide

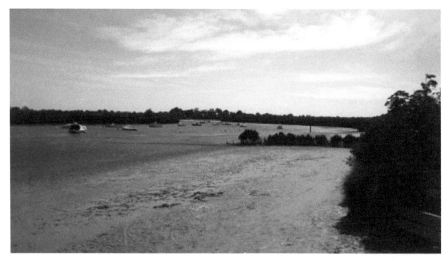

FROM WARNEET TO THE BLUFF 1

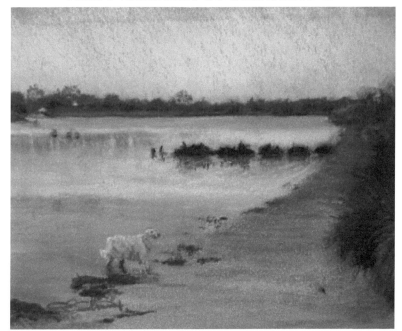

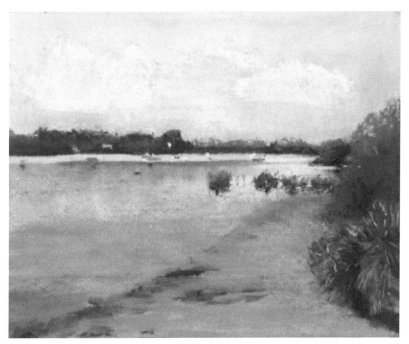

FROM WARNEET TO THE BLUFF 2

Then I was struck by Hildegard of Bingen's insight: 'there is no creation that doesn't have a radiance'.
(Matthew Fox, Illuminations of Hildegard of Bingen, 2002).

So where was the radiance of mangroves? Does every part of nature have a radiance?
I received my answer when I changed the question to:
'Is the radiance of mangroves to be found in their roles?'
By holding on to the question I found merit in that concept.

For example, the effects of light in the original photo at Gus' Jetty were definitely a rare radiance (turn back 12 pages to see my pastel version).

More importantly I discovered that mangroves mudflats are an amazing patch for crab nurseries. I just needed to gaze down to see it.

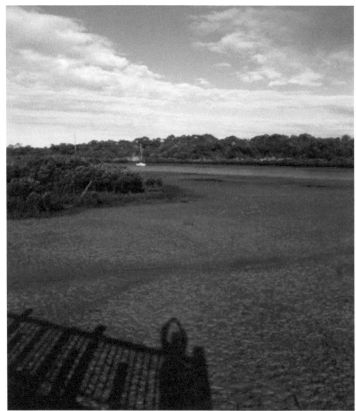

Three pages back is a picture of Mangrove Island. I've discovered that it has its own kind of radiance: the island slows the flow of the Tarwin river, reducing erosion.

Mangrove Island is surrounded by, and almost covered with, dense strands of mangrove mostly only 1 meter high. The island is in the early stages of marsh island formation.

Several large shell banks have stranded on the tidal flats south of Mangrove island.

(Source: Victorian Resources Online, West Gippsland, State of Victoria. 25/01/2019).

MANGROVE ISLAND

When 10,000 hectares of mangroves died in Northern Australia in 2016 I was profoundly affected.

According to mangrove specialist Norman Duke: catastrophic climate events of record low tides, high temperatures and evaporation confirmed to him that

'Mangroves are as sensitive as we thought!'
(Dr Norman Duke, personal communication).

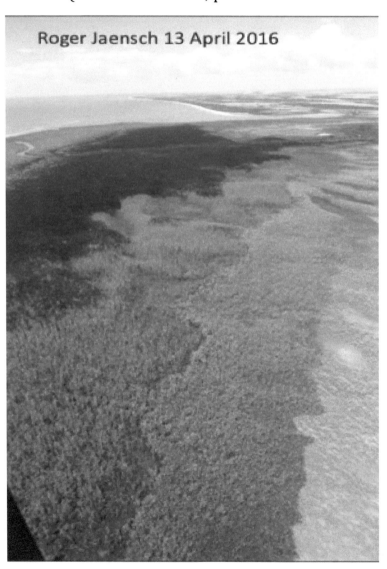

Roger Jaensch 13 April 2016

I found myself expressing my grief at this disaster using orange acrylic.

SUNBURNT MANGROVES

I am bewildered that Australians are quite indifferent in their responses
to mangroves being burnt in hot and dry circumstances, by contrast with
their intense concern for the torched eucalyptus in the bushfires.
Yet both events are greatly impacted by changes in climate, and Mangroves
are a huge contributor to Blue Carbon.

WHAT I HAVE LEARNED FROM MANGROVES.

Interacting with our world, engaging with it as honestly as possible, influences my painting. I don't believe the world– Inner and Outer– is divided into sacred/profane.
With this holistic perspective, I take notice of everyday happenings within and without, and keep finding new views of tides, plants, seasons and weather.
The Keeper of Mangroves links my inner child to 'All things Bright and Beautiful' and helps me capture some mangrove radiance where green and brown were once all I could see.

Here we might play "Spot the Mangroves' with two scenes 4 kms apart.

HAREWOOD HOMESTEAD (from the levee bank)

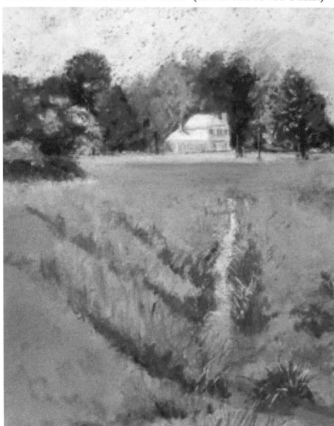

The small patch of mangroves on the upper left side is but 'the tip of the iceberg' of mangroves in this location. Immediately behind me when I photographed this spot were huge numbers of mangroves.

Now a painting of a boy on the sands at Tooradin. With the permission of his mother I photographed him making a sand castle.

I titled this work with deep feeling a month after the Turkish soldier picked-up the body of the refugee boy who drowned in the Aegean sea.

IN ANOTHER WORLD

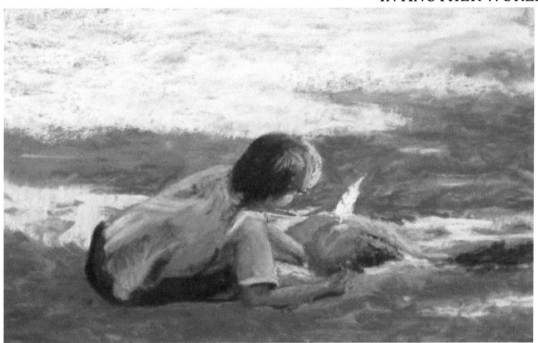

Mangroves are the only woody plants that grow in salt water and experience high and low tides.

They grow in soft sediments wherever they are sheltered from high wave energy.

Blue carbon is the carbon stored in coastal and marine ecosystems. The coastal systems include mangroves, tidal marshes and sea-grasses. These ecosystems sequester and store large quantities of blue carbon in both the plants and the sediment below.

Coastal habitats cover less than 2% of the total ocean area, but account for approximately half of the total carbon sequestered in ocean sediments!

Looking within to see what I needed to change freed me to paint more intuitively. Now mangroves, as tenacious and resilient protectors of our intertidal environment, lead me to acknowledge I too need tenacity and resilience when feeling very fragile, whatever my environment.

With encouragement from Maria Harris (Dance of the Spirit, 1991) I asked, "What are mangroves telling me about my life, my world, my past and future? Where among mangroves have I found themes of adventure, power, brokenness or growth?"

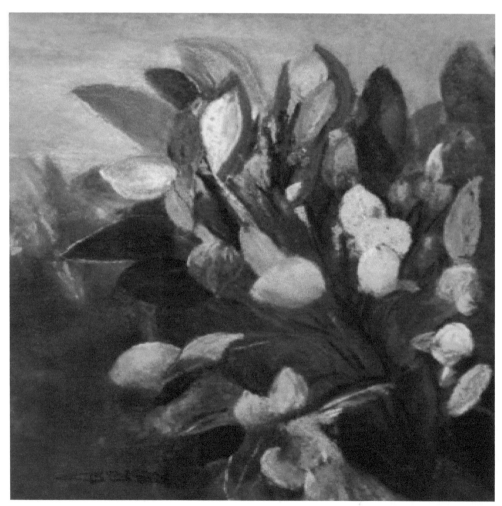

These yellow propagules are ripe for nourishing a new mangrove tree until it puts down new roots into sediment and salt water.

How will I know when I'm ready to take a leap into some-thing new?

From a photo of David Fullerton.

FRAGILE SEEDLINGS – patience in waiting

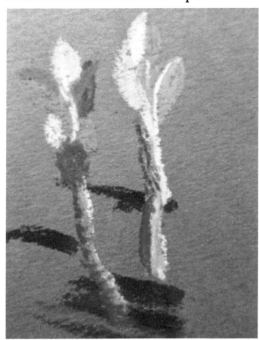

FOSTER DEVASTATION

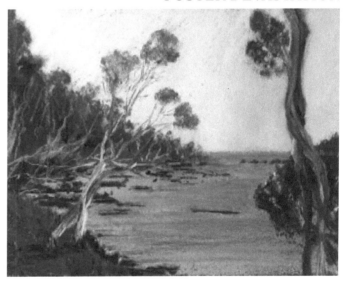

"Broken by what life tossed my way"
Guardian mangroves have been washed away
from the coastline, leaving the front lines weak and
ill-equipped when the
next storm hits.

From my community of mudflats and saltmarsh I learned that
+ Mangroves need oxygen, roots, leaves, sediment and salt water to live.
+ Tides must be welcomed for what they bring: gentle, reliable energy.
Powerful, unplanned king tides are not always welcome and their nourishing
and high energy can tend towards the addictive.
+ Gales of wind disturb water clarity and affect the nutrient balance in the
sediment. Just as wind can cause young children to be noisily unruly, I feel
that same influence in nature. It can take me hours, or days, to allow facets of
my life to rebalance.
+ I function well with a mix of daily, weekly, monthly and yearly patterns.

TOORADIN MUDFLATS

Gentle, reliable energy occurs twice daily in Sawtell's Inlet.

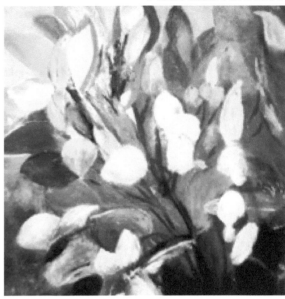

MANGROVE FRUIT

From December to January Mangrove
propagules commence to germinate
while on the tree.

RUTHERFORD INLET

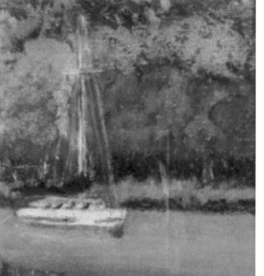

Pleasure craft can only
move when the tide is
sufficiently high for
a suitable length of time.

There must also be
sufficient tidal energy
to assist movement
of the craft.

+ Gentle daily movements in routines remind me of tides and their 'rule of twelfths', the changing rates of flow in the shifting tides 1-2-3-3-2-1. Faster and slower rates of inflow and outflow twice every day demonstrate orderly nourishment.

+ Tidal shifts of energy through inlets, channels, dendritic patterns of seeping waters provide variety in my painting, consistent with the ebb and flow of life.

+ Slack water arrives in my studio when I feel no movement in how to get past an unresolved issue in the creative process.

'Slack water', is the moment when the incoming tide pauses, before the outgoing movement begins. This idea stayed with me for 18 months until I listened to what I needed to hear. Then it talked to me of 'burnout' and 'inner work to be done' to begin recovery.

DENDRITIC PATTERNS of Western Port.
Dendrite comes from the Greek word for 'tree'. Dendritic growth is a common phenomenon in nature. This picture from Corinella shows the green branching flow on the main creeks and inlets of Western Port.

French Island Marine National Park

SLACK WATER

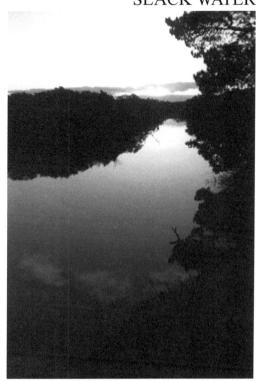

THE DAY WINDS DOWN

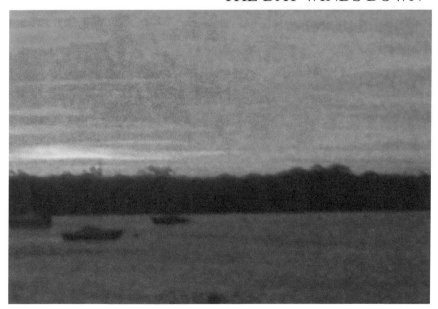

THESE GUARDIANS OF OUR SHORELINES.

I now own my emerging activism for mangroves, bearing witness to their remarkable lung and kidney-like protective and cleansing activities in our environment.

I champion the tough yellow-green propagules (freshly germinating seedlings) that fall from mangrove branches and take root in surrounding brown sediment: that collection of the all-important nutrient supply for mangrove growth.

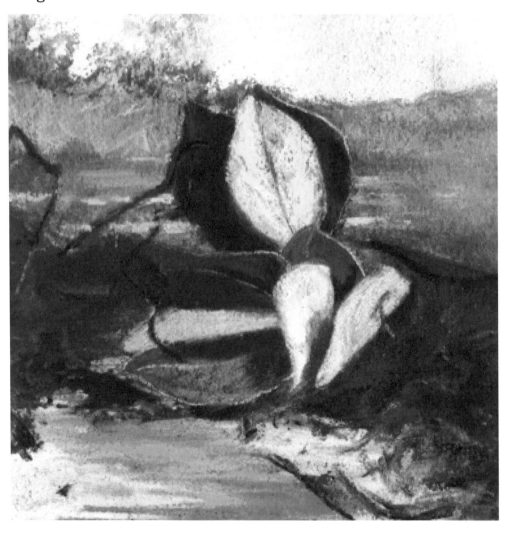

The seedlings will grow in the dark brown strip a metre landward of the mangroves on the right. This is where I found the propagule seedling that I drew (opposite).

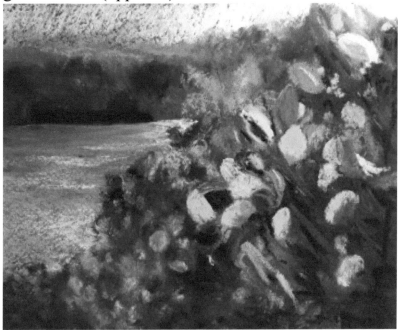

Tough yellow propagules ready to sprout & drop.

All these roles contribute to beautiful or unique effects in scenes I paint. My mangrove landscapes show environments I now value more highly, protect more keenly, and appreciate more passionately.

Mangroves have become a symbol of how I approach God in a meaningful, contemporary way. To my surprise the day my first solo exhibition was dismantled I had an 'aha' moment: "I am the Rwanda-infused green mangrove putting down my roots in the brown environment of each Western Port landscape!"

This confirmed and explained a friend's words to me: "Authentic and called describe you and your painting". I have somehow become part of the landscape and it has somehow become part of me.

I think I now know what Tim Winton meant when he said:

'We need to belong to them as if they were kin'.

Preparing for my solo exhibition:

Enjoying the
display of my
work.

Having
the
conversation.

Welcoming friends & family to the exhibition.

At WellSpring, Ashburton

Simone and I

Federal member Hon. Anthony Byrne MP with
Dr Pat Macwhirter environmentalist and bird specialist.

At the launch of Pat's
book on the history of
Harewood.

Cover art:
"HAREWOOD from
the levee"
by Sandi.
2016

Now I am moving towards understanding how Samphire contributes to the health of the inter-tidal zone, where it sits slightly higher up than mangroves. This plant is also of interest because it is being cultivated in some places as a human food crop.

SANDI: Artist & Mother of Adele

I invited my grandchildren to select a favorite piece or two.

Corey chose: STILL FISHING & PELICANS

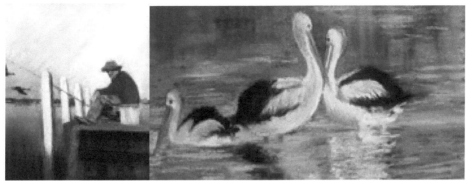

Kasey chose:
HIGH TIDE
at Bayview Road

She said
I see two pictures in one.
The top half is a bush scene & the lower half
is an underwater scene of sea and coral (like
grasses)

Elly-May chose:
FROM WARNEET TO THE BLUFF 1.

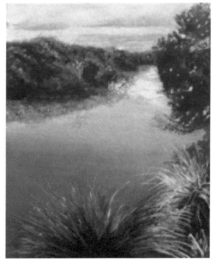

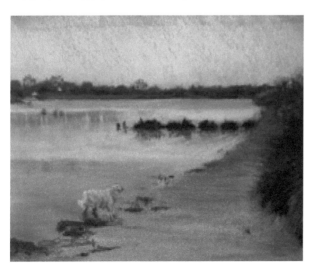

I like the dog, it is
really cute. And I love
the colours of the sand
and the water tones
next to each other.

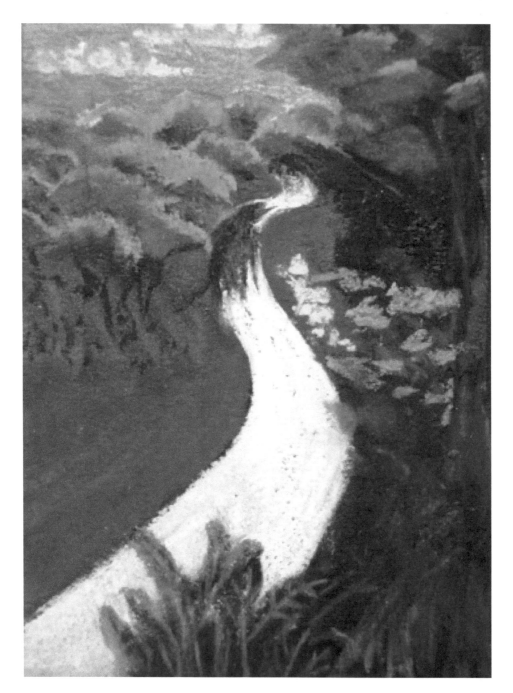

BAYVIEW ROAD – Low tide

Me and my word-processor

My recent reading:

Aboriginal Yuin elder, Max Dulumunmun Harrison (Uncle Max) says, 'Let's watch the land talk to us'. Morgan and Garrett ask, quoting words of contemporary French philosopher JL Chrétian: if it is possible he is giving expression to a 'rigorously phenomenological property of human sight'?

Morgan and Garrett suggest that Uncle Max appears to be saying: "I am trying to capture in words the beauty of the land I see around me." They go on to suggest that would mean: 'the beauty of things becomes properly visible, that is we see them truly, if and only if they speak to us, and we question them. And that implies the world is not 'an inaudible visible', but rather 'a visible voice'.

Extracted from:
Morgan and Garrett, On the Edge, Morningstar, 2018, pp19-20.

THANKYOU FOR SHARING MY JOURNEY
Sandi Steward
May 2020

 CPSIA information can be obtained
at www.ICGtesting.com
Printed in the USA
BVHW020953250520
580271BV00003B/7